December '06
to Peggy,
With all our love,
Hopie and
Dein

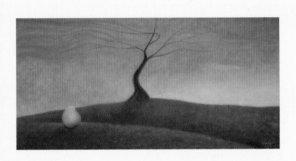

This is
the Land
of Two Suns

Paintings and Poetry

SHELLEY LOWELL

Curated and Edited by

MITCH M. ANGEL

(cover)
Living Fragments 2004
24 x 48

Cover and Book designed by Shelley Lowell

The paintings in this book represent a body of work
exhibited at **Montage Gallery** of Federal Hill, Baltimore, MD
in April 2005, *Land of Two Suns*.
www.montagegallery.com

Paintings: Dimensions are in inches; height precedes width.
Dimensions describe work as a whole.
Medium of Paintings: oil and wax on canvas

First edition printing limited to 2000 copies
Printed by Bladen Lithographics, Inc., Gaithersburg, Maryland
ISBN: 0-9765344-0-1

Acknowledgments

This book, my paintings and poems would not have been possible to create without Mitch M. Angel. He is an angel in my life. He saw in me what I could not see in myself and pulled it out of me. Somehow, he knew what no one else did. And he trusted in me. I am forever grateful to him.

Then there is my dear friend, Wendy Marilee, who spurred me on and knew from the day we met, that my life's purpose was to create. She has been my cheerleader, friend, mentor and advisor. Without her, I wouldn't be who I am today. She is a constant blessing in my life.

I thank Julia Cameron whose book, *The Artist's Way*, made me realize that I was doing it all along and I just had to keep on doing it.

I thank my artist friends in my Artist's Way Group who joyfully and enthusiastically support me in my creative journey.

I thank my friend who financed the printing of this book and chose to remain anonymous.

I thank Andrea Krupinski and the staff at Bladen Lithographics, Inc. for their efforts to make this book the best quality possible.

I thank my creative muses, guides and angels who have stood by me and co-created this work with me. They are, literally, a Godsend.

I thank my mother, Vivian Lowell, who unknowingly, gave me the gift of time to create these paintings and poems. I thank both my mother and my father, Allen, for encouraging me to create when I was a child. This gave me the courage and desire to always explore my creativity.

Shelley Lowell

Table of Contents

Introduction 9

Introduction

At the Beginning

As much as I would like to focus entirely on the body of work of paintings and poetry by Ms. Shelley Lowell, I feel compelled to start by telling the story of its origins, its creation, and its evolution.

I had the privilege of working with Ms. Lowell, an ongoing curating of her artwork and editing her poetry. Shelley Lowell, a talented Baltimorean artist since 2002, was born (1946) in the Bronx, NY and educated at Pratt Institute (BFA), Brooklyn, NY. As a 1970s NYC feminist social commentary artist, she produced monumental artwork as a counter statement to what she felt was the demeaning aspect of the sexual revolution of the period. Ms. Lowell owned her own ad agency in New York City and in Atlanta, (GA). Her creative graphic designs and illustrations were published and won national awards. Thus, Shelley's artistic ability has developed over the past 30+ years, in which a paralleled creative line between her fine arts, her commercial design and her art poetry was kept. Ms. Lowell exhibited her artwork in galleries and museums such as: The Bronx Museum of the Arts (NY) and the High Museum of Art (GA). As Ms. Lowell was trained originally as a conceptual artist, her artwork adhered to that. She used metaphors to convey a message and her artwork subject matter has been mostly around nature and its spirituality. Her personal and artistic outlook at her surroundings was therefore through a spectacle of living in a spiritual reality. The artist's artwork of trees with "puffs" of energy, was as if she "was walking through the fog," her legs grounded and "her vision piercing through it." Prior to this series, Shelley painted imagery of a bird's eye view of riverbeds as a part of her paintings' scheme. One of the paintings caught my attention, a piece called "Cosmic Changes" (2003). Looking at the upper part of the painting, I noticed that the riverbed image she painted also appeared to be a tree that was different – an image of a "horizontal leaf mass tree."

I suggested she paint the upper portion of the painting as a basis for a new body of work, as I saw a huge potential in the imagery and so it happened; as this book is a testament to that, to her openness and adaptability and to her creative spirit and talents.

From Vision To Reality

As this body of work was born out of planned or directed approach, its creative process eventually took it over. Once the first painting "Last Tree Standing" was painted at its initial stage, it was clear to Shelley and me the uniqueness embodied in its imagery, the power inherent in its tree and it's potential–conceptually and narratively. The goal was creating more pieces around the same concept yet keeping its edge in each and every one of the following pieces. The dual task at hand was to keep its minimal imagery, which helps to create its edge and emphasize its uniqueness, yet to explore new singular visual vocabulary from Shelley's inner-self. As we met weekly, did mental exercises and writings and worked as a catalyst to explore more visual vocabulary, a new well of freshly created paintings emerged. New ideas and imagery surfaced, (as it seems that some were waiting for awhile to come out), tree stumps that looked alive, yearning with bird-like beaks, ponds reflecting trees from the past, trees that glow internally, beacon trees, landscape with human features of lips and legs…criticism was discussed. The paintings were taking shape, color, and form. At a certain point in time when the paintings were partially finished, recognizing her multi-talented potential, and seeing her poem "The Relationship," I asked Shelley to write poems that would accompany the paintings. The poetry that followed came fast and changed some of the approach, since it added additional feedback to the paintings of clarifying and strengthening their conceptual outlook. The two bodies of work, the visual and the literary works became one. During that process the decision to create this book was done. Most importantly, the followed paintings participated in the conceptual, narrative and philosophical evolution in the short span of time of several months.

What is the "Land of Two Suns"

Since we can no longer separate the paintings from the poetry, I will regard them as one. Looking at the works, the main concept encompasses narrative surreal minimal imagery and repetitive use of "stretched" imagery, mainly trees and bodies of water. Ms. Lowell takes us and herself on a voyage-in-time of vision and dream, with an edge, narrative quality and a message. Each painting and poem takes us to a different reality with a different story.

Even though one might perceive the work at its face value–about nature and humanity, its effect is clear. Her minimal (imagery) habitat has a message–a reminder and a warning–of past and future humanity and humanism. The artist uses this singular and minimal imagery to strengthen and emphasize her visuals in what may seem in some cases as barren land.

Shelley uses trees and nature as representative of reality and as metaphors, while its cycle of rejuvenation is an allegory of human qualities and condition. The artist's trees twist and turn, sway and stretch, they take on a role of lovers (see "Lovers"), seduced by nature's music (see "Winter Dream"), give in to the force of nature with narrow profile and slim trunk (see "Cellular Memory") and act as a witness of nature "I am the last tree standing" (see "Silent Witness"). Where is the artist in all of that in terms of place and time? The artist acts, perhaps, as a changing persona as her trees change; manifesting human qualities while nature acts as a guardian of humanity. The over and under tone of this body of work is positive and hopeful. "My body exists no more, but can be seen" (See "Preexistence") and "When all is Dark...Sit Beneath a Tree..." and she concludes as the tree is also a beacon of light, "This is Your Way Home" (see "When All is Dark"). Seeds of renewal contained in pods (see "Signs of Life") and in floating blobs (see "Waiting Field") are already there, waiting. One can look at her paintings and poetry as a manifestation of her and our fears and hopes.

As "dual realities" are explored (see "Omnipresence") in vision and dreams as a state of nature and humanity and as a state of mind, does it matter which one is the "real" reality, and which one is ours?

Water, lakes and reflections of pre-existence are other significant components in the works, as the artist exhibits to us the healing and revealing power of tears "...I cried, my tears soaked the earth forming lakes. Lakes reflecting my children as they were..." (see "Powerless").

The difficulty of the minimal imagery created uses its effectiveness as it gives it inner strength and glow (see "As Time Stops"). A message of insight with no-sugar-coating is delivered about inner beauty and strength as our tree declares "I am a lone tree... but I am not alone" (see "The Sentry"). We learn about the "wisdom" of nature and its nurturing effect (see "Prairie Tree") as much as women's nurturing effect (see "Twilight"). That led us to the question "Who is in charge?" in the large sense of it. Existing forces or the everlasting "superior" forces of life, soul and rejuvenation. With trees representing the human spirit, nature's paralleled reality, our reality, ruins and seeds of renewal, the conceptual (visual) and the philosophical (narrative) come together; we have to decide which tree suits us, for our flight of fancy or just for a sit down under a tree.

Mitch M. Angel

This is the Land of Two Suns...

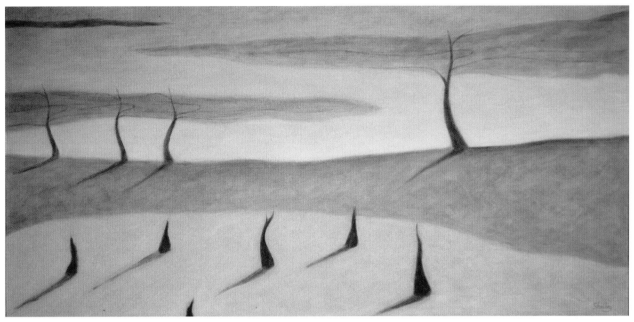

Living Fragments
24 x 48
2004

Land of Two Suns

This is the land
of two suns

Where trees
never die

Like starfish
once cut down

Once even single root
will grow again

Rejuvenated, by
their everlasting soul

This is the land
where trees
never die

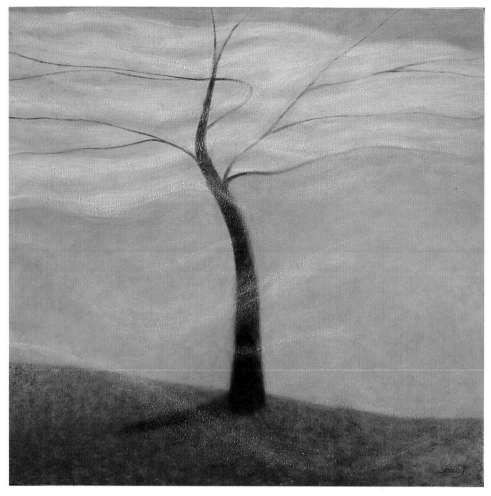

On the Edge
36 x 36
2005

On the Edge

I stood on the edge
Roots grasping the soil
fearful, I would fall.
Fall into the abyss,
turbulent swirling sea.

I can't swim
All these limbs,
can't swim
Ocean leaped up
Waves slapping

Teasing,
taunting me,
"Let go!"
"Fly," it said.
"Fly, I will catch you."

It laughed
spraying salty moist air.
Wind whipping,
I gripped eroding earth,
holding on.

"Jump! Jump!"
"I will catch you!"
Waves beckoned
Earth slipped
out from under.

Spinning,
falling, falling…
Then, suddenly
I felt morning sun warm
my dew laden leaves.

Peaceful meadow
Roots firmly planted
encircled family, friends
swaying in the
Summer breeze.

A dream!
It was all a dream.
Morning breeze
peaceful meadow
firm roots.

Sacred Ground

Fertile field
young souls sleep.
Seeds of life purpose
grow inside.

They lay ready
path imprinted
waiting
for their partner's birth.

Tomorrow's earth children
enlightened messengers
unconditional love
everlasting peace.

Listen to these children
Tomorrow's children.
They are humanity
Last chance.

Waiting Field
20 x 40
2005

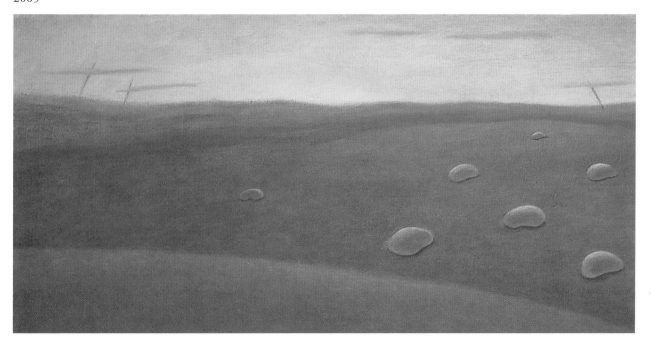

Silent Witness

Still I am confused,
bewildered, perplexed.
How could a species so intelligent
do that to their own?

I've seen this happen
time and again.
Each time I wept.

Not for food.
These upright beings.
But for power, control, greed.

I've seen this happen
time and again.
Each time I wept.

It will happen no more.
They are gone.

I've seen this happen
time and again.
Each time I wept.

The forests. The animals.
All gone.

I've seen this happen
time and again.
Each time I wept.

I am the last tree standing.

Last Tree Standing
24 x 48
2004

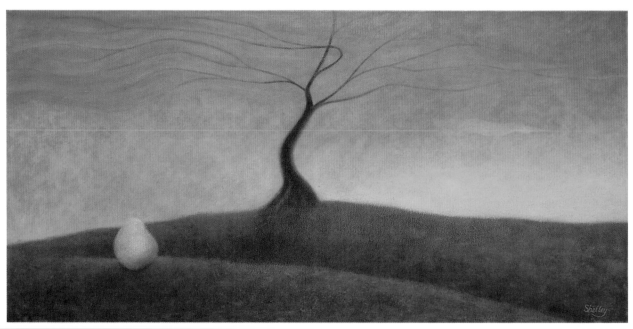

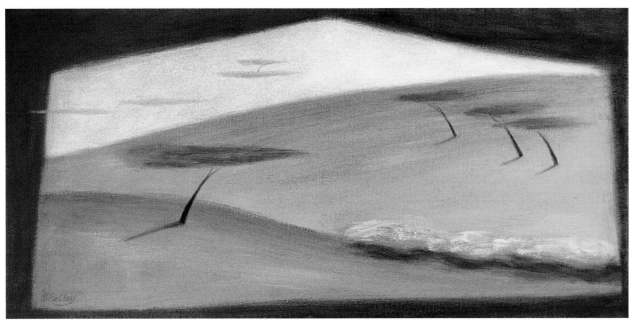

Cellular Memory
12 x 24
2004

Remembering

I remember standing tall.
Birds singing
nestled in my limbs.
Rush of wind through
my glorious green tresses.

I remember the day
I was downed
milled planks
dead wood
Dwelling for those who downed.

Birds no longer flock to me.
Their song
a distant melody.
The wind
pushes passed me.

No one knows me.
A tree, I will always be.
Nature's partner
same meadow.
A tree, I will always be.

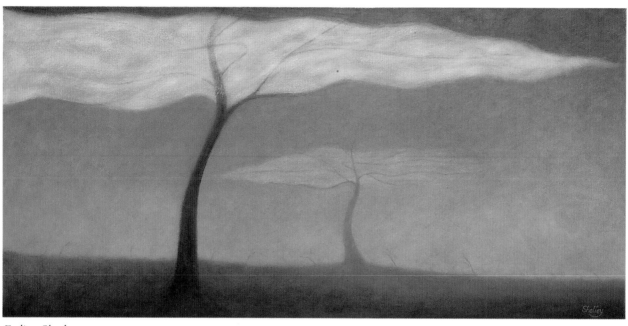

Fading Shadow
24 x 48
2005

My Daughter

That is my daughter
elegant, graceful, slender and tall
She is so full of herself
such a know-it-all teenager

Now, I stand in her shadow
once as elegant as she
Once as know-it-all as she

Now, in her own,
she thinks I know nothing
can do nothing right
She acts like I have grown old and dumb

She struts with
that I-know-it-all stance

I stand here in the shadow
Waiting
I stand for the day she comes around
Waiting
for the day she has her own daughter

I stand here for her
waiting her to realize

I gave her
knowledge, guidance, and love, so
she can stand there
in her glory

I stand here in the shadow
Waiting
patiently, lovingly waiting
I stand here in our shadow

The Relationship

The tree stood
alone
on the hilltop
each leaf still
reaching for the sky
loving the light

A breeze came
He caressed
each leaf
each limb
The tree swayed
They danced together

The tree
enchanted
by the breeze
grew to love
his gentleness

The breeze grew stronger
The tree began to bend
not really noticing
the change

The breeze grew stronger
He became a relentless wind
The tree cried out
 "Stop
 stop
 stop you're hurting me!"

The wind did not heed her
He continued his steady gale
So happy was he
So in love with this
beautiful bending tree

For the tree
light turned
to darkness

The tree bent
and bent
and bent even more
Then she cracked
She pulled herself
roots and all
out of her earthbound home

She rolled and tumbled
rolled and tumbled
down
into the valley below
Free
from the wind
at last

Bruised
hurting
future uncertain
still the tree rejoiced
feeling relieved
renewed
full of light again

The wind bellowed loudly
for all to hear
 "She left me.
 How could she do this to me?
 I loved her so."

Taken by the Wind
20 x 40
2005

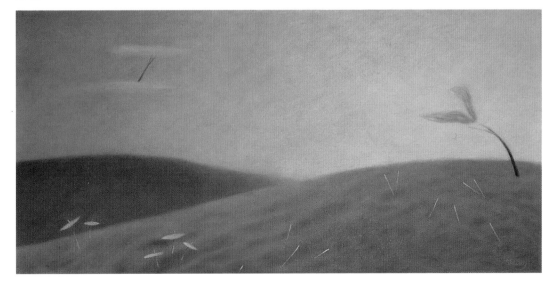

19

When All is Dark

When all is dark
When you are lost
Sit beneath a tree
Silent beacons
of light, hope, love.

Relax. Breathe.
Quiet your thoughts
Feel the light
glow your heart.

When it is dark
sit beneath a tree
Relax. Breathe.
Trust and know.
This is your way home.

Beacons of Light
36 x 60
2005

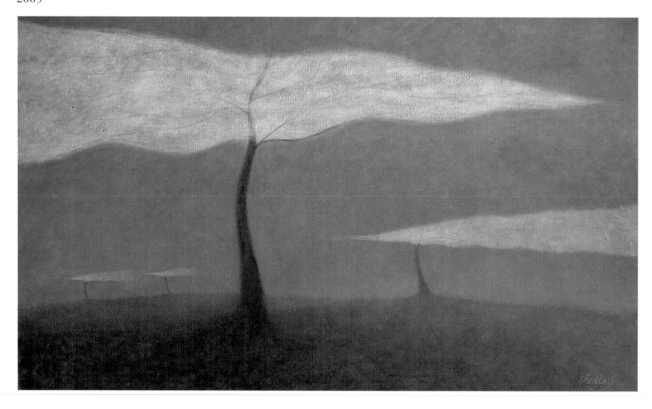

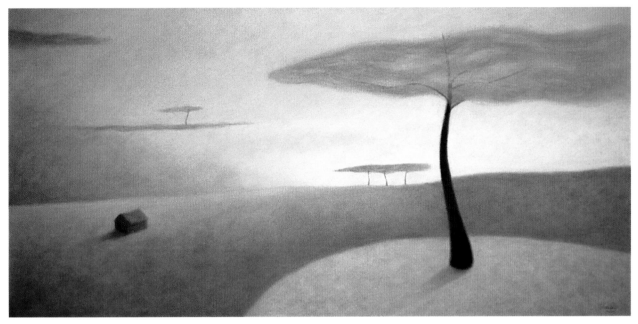

Night Cabin
24 x 48
2005

The Sentry

This is my terrain.
Standing watch.
Earth's guardian,
keeper, protector.
Day into night
night into day
always.

Trees nearest
miles away.
But I am not alone.

Winds whisper
massaging my body.
Birds coo
nesting in my leaves.
Animals chatter
gather beneath my limbs.

That is not all.
Trees past
Trees present
Trees distant
worlds beyond
visit through thought
through visions.

Trees nearest
miles away.
But I am not alone.

Physical space
is only one place.
We are together
multiple levels.
There is more
then what is seen.

I am a lone tree.
But I am not alone.

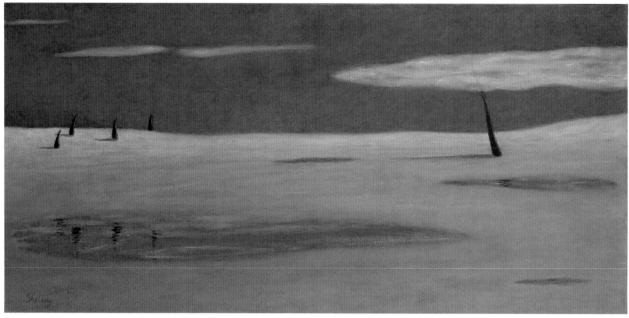

Reflection
24 x 48
2005

Powerless

I tried running.
My body
too well rooted
could not move.

The wind pushed me.
Still my body
could not move.

Powerless
I watched, witnessed
the ruins.

In sadness
pain and grief
I saw their remains

Alive
souls intact
trying to come to me.
Trying to grow.

I cried.
My tears soaked the earth
forming lakes.

Lakes reflecting
my children
as they were
before man came.

One Mind, One Heart

We share
one mind
one heart

We are
all connected

Your energy is
my energy

We are
all the same

We only appear
in different shape and form

We share
one mind
one heart

Shall Mother Earth rise up?
Will nature force us?

To open our heart
reach out?

Different values and beliefs
sum all the same

We only appear
in different shape and form

Omnipresence
48 x 36
2005

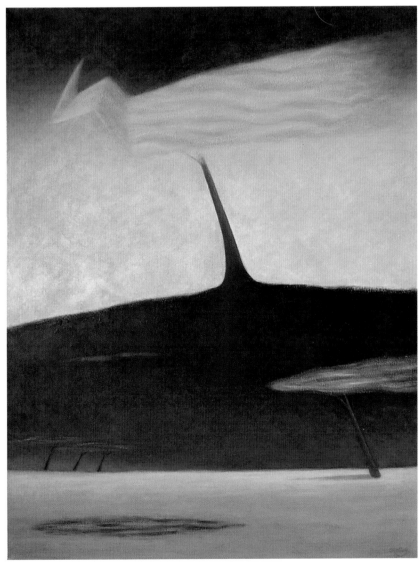

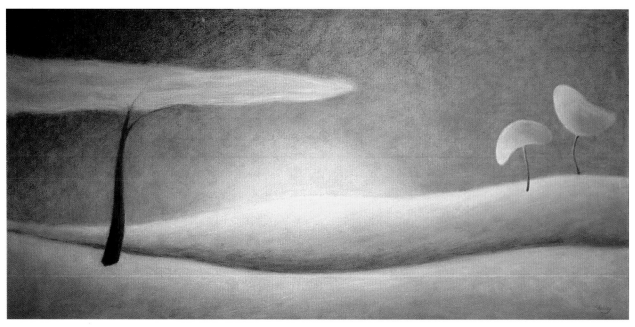

Plastic Lips
24 x 48
2005

Valley of the Heart

In the valley
of the heart
there is no night.
There is no sun.

The valley,
trees of wisdom
trees of joy
pulse
luminous light
eternally.

There are
no shadows.
No sadness.
Serenity,
peace and love.

This valley
is within you.
Go there.

Prairie Tree

The bushes ran
around the dwelling
playing, in the last
of the evening sun.

The dwellers
back from the fields
rested after a long day
in the sun.

And the tree
the tall stately slender tree
proudly watched over
protecting with love.

Grateful she was.
They planted her
they nourished her
theirs she was.

Evening Sun
24 x 48
2005

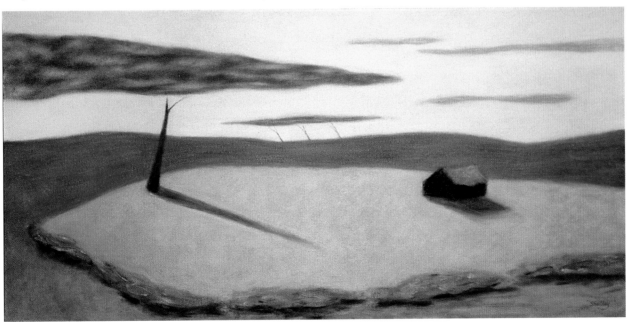

Lovers

We dance in the light
of the midnight sun.
Kiss in the shade
of the noonday moon.
Embrace as balmy breezes blow.

Shared dreams,
desires, passions and views.
This is our secret.
Connected on many levels,
as one we stand.

Young lovers
walk hand in hand
beneath.
Our limbs intertwined.
Feel our love,
theirs too.

They leave
our leaves
unaware.
We are lovers too.

Intertwined
12 x 24
2004

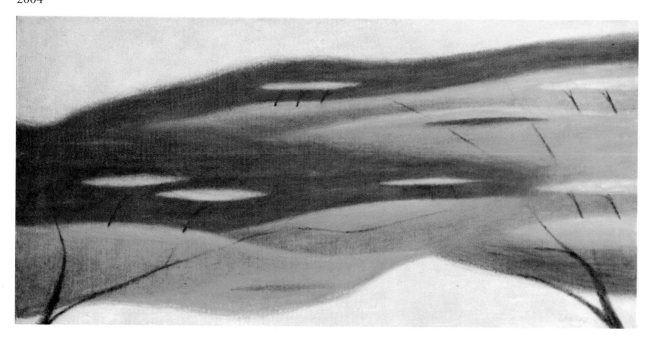

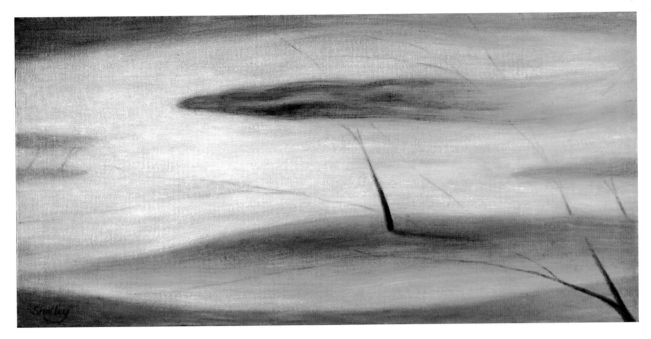

Winter Dream

My energy has drained
back down to my roots.
My branches have
released its leaves.

I stand bare
in a winter's scape
enveloped in frost air.

Slowly, my self retreats
relaxes, drifts into blissful sleep.
Slowly, the outside world falls
away.

No longer do I see
naked branches
gray skies above
brown grass below.

I sleep, I dream.
My heart sees
a lively meadow
rich in greens and yellows.

Trees in full dress
sway to birds' song.
Earth in perfect harmony,
Love abounds.
White skies lit by sun's glow.
Peace among all creatures.

Slowly, my energy
returns to my branches.
Slowly, my leaves bud.
I awaken.

But my heart yearns
for the dream
to continue.

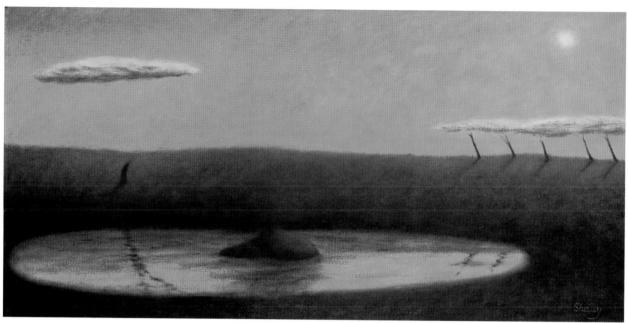

Water's Mirror
24 x 48
2005

Preexistence

They took my body
not my soul.

On days
when the wind quiets
and the lake stills
I can be seen

As I once was
intact
in all my beauty
reflected in water's mirror.

My body
exists no more
but can be seen.
My life force
lives on forever.

Twilight

As the sun sets
the moon rises
Time stops.

Tree fairies come out.
Little beings of light
dance on hilltops
play beneath the moon
spreading joy, love and innocence.

Elder trees, wisdom trees
watch
longing for those days
when they lived in innocence
when earth was at peace
when man's ego slept
women ruled
with a nurturing hand.

As the moon sets
the sun rises
Time stops.

The fairy trees go to rest.
The elder trees, wisdom trees
dream
of the dawn
when men put down their arm
Earth is ruled
once again
with women's hand.

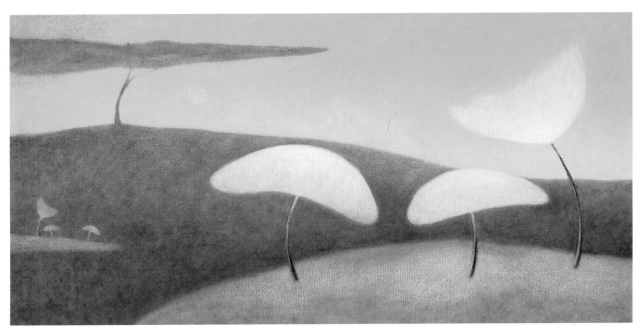

As Time Stops
24 x 48
2005

Signs of Life

Centuries passed.
Earth stood still
stuck in time
void of life and growth.
All lost, in man's final war.

Centuries passed.
Time unravelled
Earth began to turn.
Sun slipped into sleep
Moon awoke.

In the dawn
pods lay growing
pulsing life, glowing light.
On barren land
trees sprouted.

Time passed.
Foliage thrived.
Nature dreamt of a day
new breed of humanity
return.

A species cherishing
pulsing life,
its own and nature,
knowing, they all are one.

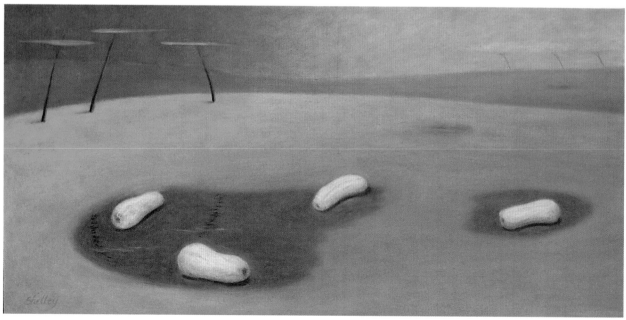

Ponds
20 x 40
2005

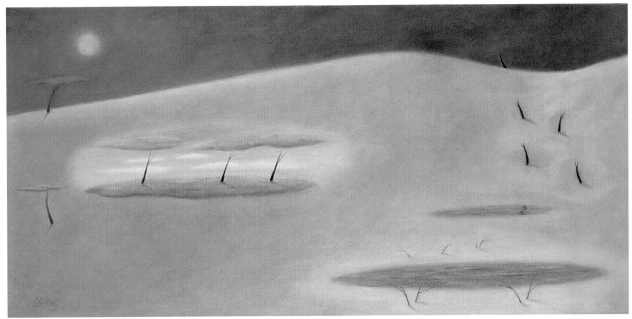

Time Travelers
20 x 40
2005

Visit

When the moon
is full and high
Earth blanketed
with white,
we visit,
survey and reminisce.

This was our valley.
Here, we bloomed, grew,
bore children.
Bushes danced with us.
Ponds swelled
prideful of
fish harbored.

Fragments of our beauty
stand where we stood.
Cold air blows
Bushes dance no more.
Ponds lie lifeless.
We are not there.

This is our valley.
When life returns
sun is high
warm breeze blows.
We will return.
Here, we bloom and grow
again.

Until then, we visit
survey and reminisce
with sorrow and hope.
This is our valley
beauty restored
warmth in our hearts.

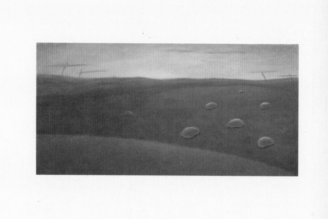